"**Black Disabled ART HISTORY 101** is a wonderfully illuminating and thought provoking read. Leroy Moore's affirming and inviting voice welcomes the reader into an exploration of a history known to too few. Though written for disabled youth, this text is worthy of a wider audience, as it offers an unapologetic look at disabled Black artists from an asset based stand point. Moore's encouragement to give voice to his poetry serves as the connective tissue between the chapters and vignettes, and provides an additional somatic experience that transports the reader to another level."

—Milton Reynolds, Bay Area Educator,
 Activist and Change Agent

"**Black Disabled ART HISTORY 101** is a rhythmic roll-call, naming and claiming black disabled artists whose work deserves a much broader audience. The text remixes identity and creativity into an altogether new cultural record that defies categories and expectations. Documenting the complex interplay between art and embodiment, Leroy F. Moore, Jr. has assembled an aesthetic archive that refuses to allow racist and ableist histories to have the last word. Instead, the reader is offered a living lexicon to speak with, not about black disabled artists, encouraging us to continue the conversation well beyond these pages!"

—Ruha Benjamin,
 Professor, African American Studies at Princeton University

"I believe that Leroy Moore opens a big door that we may not have known existed. In his book, Black Disabled Art History 101, he introduces the world to many accomplished artists and activists who defied their disabilities and mastered their creative intelligence into substance. It is filled with some amazing stories, images and words of wisdom. It is both purposeful and motivational, as he educates on the "emerging definitions" that celebrate art and humanity."

—Deborah Day, CEO and Founder,
 Ashay by the Bay Children's Bookstore

"Leroy Moore's work clearly follows Toni Morrison's sage words, "If there's a book that you want to read, but it hasn't been written yet, then you must write it." Yet Moore does not simply write a book, but breathes fire into its pages. Through his own poetry, interspersed within the visual art, pictures, and stories of Black Disabled Artists, Moore's book brings to life the history of art in the Black Disabled Community. He both teaches about individual histories and creates a mosaic of the community of Black Disabled artists. Bringing these stories together illuminates what had previously been empty spaces, filling children (and adults) with much needed knowledge about Black Disabled Art History. This book is for anyone who loves art, hip hop, poetry, and/or history."

—Subini Ancy Annamma, Assistant Professor,
 University of Kansas

"It seems to me that the privilege of ability, above all else, is the ever present and least acknowledged structure of exclusivity and inequity in our society and institutions. A prophetic storyteller, Leroy Moore presents the narratives of American sheroes and heros that most of us are completely unaware and invites us, through his beautiful truth telling form, to be more honest, more conscious human beings to this reality."

—Mary J. Wardell,
 Chief Diversity Officer, University of San Francisco

Black Disabled

ART HISTORY 101

Leroy F. Moore Jr.

Black Disabled Art History 101

Copyright © 2017 Xóchitl Justice Press

All rights reserved.

Xóchitl Justice Press, San Francisco, CA

Library of Congress Control Number: 2016955650

ISBN: 9781942001577

First Edition June 2017

10 9 8 7 6 5 4 3 2 1

Black Disabled
ART HISTORY 101

Leroy F. Moore Jr.

Edited by Nicola A. McClung and Emily A. Nusbaum

Dedication

This book is dedicated to all the disabled children and youth searching for a mirror, for histories, for stories, and for images that say, "You are not alone. You are being carried by disabled Black and Brown adults who were once disabled Black and Brown children and youth. We want you to continue on your path and lead others in new directions." This book is also dedicated to my nieces and nephews: Sasha, Lucius, Mordechai, Atticus, Ace, Lighting, Cake, Angelina, Sabastin, and Tiburcio.

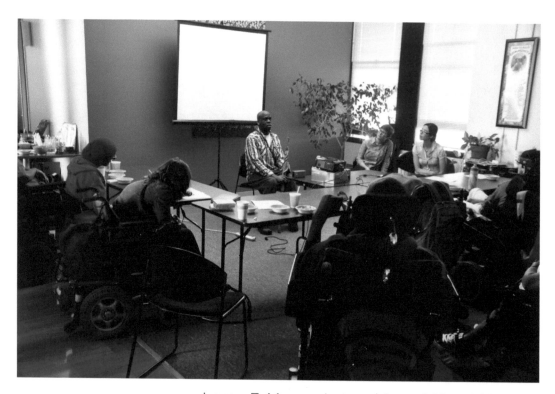

Leroy F. Moore Jr. teaching at Hand-N-Hand
Oakland, California, 2015

Identity-Based Language

Identity-based language is used throughout this book. Unlike person-first language, which places "the person first, then the disability," identity-based language positions disability as an identity that can be proudly claimed and is only negative because society makes it so. The artists featured in this book are not celebrated because they have overcome their disability. Rather, they are celebrated for their creativity, which is deeply intertwined with disability.

Table of Contents

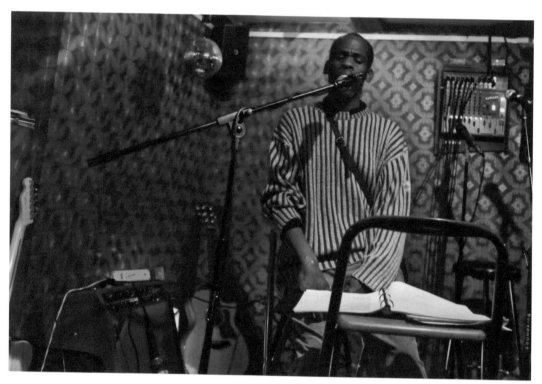

Leroy F. Moore Jr. in Copenhagen, Denmark, 2004

Introduction

I was born in New York in 1967 with a physical disability called **cerebral palsy**. As a youth, I found many of my Black disabled **ancestors** in my father's record collection. I discovered Blues, Jazz, and Soul performed by blind artists and by artists on crutches.

Leroy F. Moore Jr.'s books and records

I didn't realize it then, but these records gave me the strength to face teachers and other adults who constantly told me that there were no artists who were Black and disabled like me. These records inspired me to learn about Black disabled artists and authors creating visual art, dance, poetry, music, and literature.

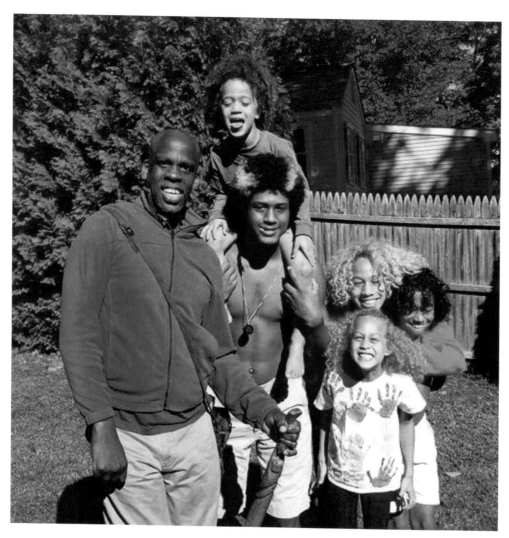

Leroy F. Moore Jr. with family
(Lighting, Lucius, Sasha, Mordechai, and Ace)
Suffield, Connecticut, 2016

You will notice poems throughout this book. These are part of my contribution to art history as a Black disabled man. They remind me that I am a part of what challenges America to grow through the arts and activism. I wrote them to not only honor the artists' contributions to American history, but also to remind disabled children and youth, and youth in general, that they are inheriting a rich history of art and activism that they can take pride in and add to. I invite you, reader, to speak them aloud, and let them be the soundtrack of this book.

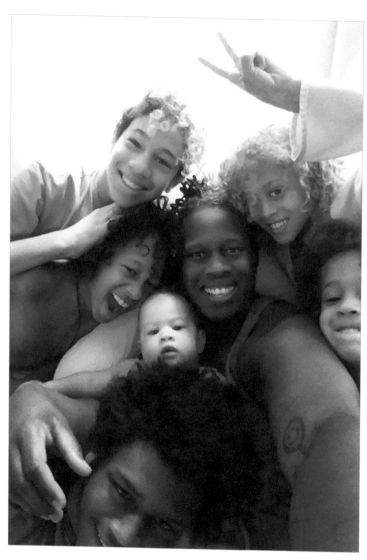

Leroy F. Moore Jr. with family
(Lighting, Lucius, Sasha, Mordechai, Melissa, Cake, and Ace)
Suffield, Connecticut, 2017

This book offers a small portion of the Black disabled art history of the United States of America, including some well-known artists, and some local Bay Area artists who are carrying forward Black disabled and Deaf art and activism. Many notable Black disabled artists are not presented in this book, and others, such as Ray Charles, CeDell Davis, and Brigardo Groves are simply featured in the poems. It is a history "to be continued"—your generation, like mine, will add to this tradition of Black disabled art. Like my father did for me, I invite you to learn more about the artists within and beyond the pages of this book to guide your way into art history.

Leroy F. Moore Jr.

Black Disabled Art History 101

Sit down & listen
cause there will be a test at the end
displaying & speaking
our history & culture
through music, art & dance

From slavery to homeland security
Black disabled artists'
roots grow deep
however this garden is starving for recognition

The most famous classical pianist
in the mid to late 19th century
was a Black Blind Autistic slave
Tom Wiggins aka Blind Tom was his slave name
his master used him to make money
and left him poor and broken

Horace Pippin, the first Black Disabled self-taught painter
lost his arm in WWI
using his left arm
to prop up his right forearm
crafting his first masterpiece depicting horrors of war
oh, the price he paid for being Black, Poor,
self-taught & Disabled

Blues is the Black Anthem
attracted blind singers & musicians
to make a living on the streets
some made it into recording studios

Blind Willie McTell born in 1898
played on the streets of Atlanta
Blind Willie Johnson born around 1902
a street evangelist

stepmother threw lye

in young Johnson's eyes causing blindness

Johnson became the first

gospel guitarist to record

he died of pneumonia

hospital refused admittance

due to his blindness

Blind Blake & Blind Boone's

Birth dates are not known

Blind John William Boone formed

his own concert company

traveled all over the country

more than 8,000 concerts

in the USA, Canada, Europe & Mexico

The most popular Male Blues
recording artist of the twenties
was Blind Lemon Jefferson
he was also a street performer

Dance to the Blues, Rock, Jazz & Hip-Hop
Vibration under The Wild Zappers
A Black Deaf dance troupe
Feeling the rhythm
From the Motherland to Chocolate City

Listen to the Melody Heartbeat of a Black Deaf Woman
Jade's fingers read I'm a proud Black Deaf Woman

Let's travel to Jamaica
where in the fifties polio infected the island
Skelly, Wise & Apple are Israel Vibration
they met each other at Mona Rehabilitation Center
got kicked out cause their religious beliefs in Rasta

homeless, poor & disabled

began to sing on the streets

now they are the Fathers of Reggae

Back to Africa tribal dancing

to the drumming, guitar strumming and singing

of Amadou & Mariam

a blind married couple

blending Rock, Pop, Jazz & Hip-Hop

with an international flavor

from Cuba to Asia & India to America

Creeping into the Hip-Hop Nation

Paraplegic MC, Fezo Da Madone & The Black Kripple

lifting the roof of oppression that suffocates the

Hip-Hop industry

throwing away the Bling-Bling

to create Krip-Hop politicizing our communities

Coming home to the Bay Area

to swing from Charles Curtis Blackwell & Avotcja's

jazz Poe-tree & celebrate

so get out your number two pencils for your final on

Black Disabled Art History

"Black Disabled Art History 101" by Leroy F. Moore Jr.
First Published in *Black Kripple Delivers Poetry & Lyrics*
Poetic Matrix Press, 2015

Visual Artists

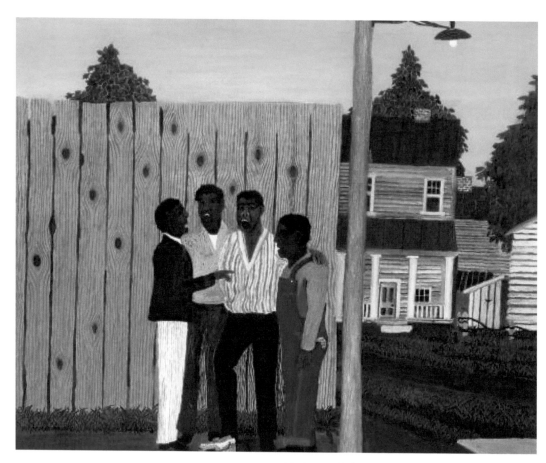

Harmonizing, 1944, by Horace Pippin

Horace Pippin
1888–1946

If you injured the hand you use to write, what creative solutions could you think up in order to make art? After Horace Pippin injured his drawing arm in World War I, he taught himself to paint with his wounded right arm by guiding it with his left hand. He also used a hot poker to burn images onto wood. It took three years to complete his first painting—now that is dedication, never giving up! Pippin's art reflected his life experiences, including going to war and living in America as a Black man. Who would have thought that a Black, poor, WWI veteran with a wounded arm would become a famous artist?

"Pictures just come to my mind, and I tell my heart to go ahead." —Horace Pippin

Break the Frame; Tell it Like it is

A broken frame
eliminates Webster's definition

Art comes from within

Horace Pippin
self-taught, who would have thought
a Black, poor, WWI Veteran
with a wounded arm
became the foremost artist
of the twentieth century

"Pictures just come to my mind,
 and I tell my heart to go ahead."

Decorating discarded cigar boxes with charcoal
Creating his own unique painting style
burning images on wood panels
using a hot iron poker for the color

Pippin opened a new avenue
leading to a display for public view

Colorful and painful experiences scratching to get out
years of his creative therapy equaled
"The End of War: Starting Home"
by using his left arm to prop up his right forearm
crafting his first masterpiece that depicted horrors of war

Haunting memories
surfaced a deep depression
painting was his medicine

Reminded the country
"there was war then but there will be peace again"

Saw more discrimination
against the next generation of Black soldiers in WWII
"I paint it exactly how I see it!"
Mr. Prejudice

Waiting for Black soldiers back in the U.S.
supported by his family
traded his paintings in lieu of payment for food
at Black businesses in PA's West Chester community

Free from influences of academy
expressing himself in his own way
finally received some recognition

The price he paid
for being Black, poor, self-taught & disabled
caught him in two worlds
took a toll
although his paintings sold
Pippin lived on the brink of poverty

Felt the pressure of the art industry
broke up his family
wife addicted to diet pills
trying to get Pippin's attention
had a breakdown and slipped into a mental confusion
she died in a mental institution

Look into the eyes
of the "Man on a Bench"
tells Pippin's story and depicts the future
of Black painters
who followed in Pippin's footsteps

Names and messages almost faded from art history
A few Black scholars have put them back on the page
and in art galleries

But very few go into depth about their disability

A broken frame
opens up the mind to endless possibilities

Like Pippin adapt to your situation but always display
People's beauty, the inequalities and injustice in society

"Break the Frame; Tell it Like it is" by Leroy F. Moore Jr.

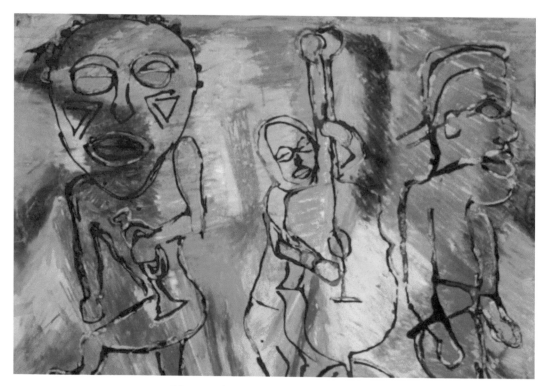

The Melody In-Between the Truth of the Matter, 2010
by Charles Curtis Blackwell

Charles Curtis Blackwell

1950–Present

When you close your eyes and sing your favorite song, do colors, shapes, and pictures in your mind accompany the music? After losing his sight, Charles Curtis Blackwell's mind filled with images of Jazz that he brings to life through poetry, painting, and song. Blackwell paints with his fingers, the bottom of a brush, and even three colored pencils at one time! His paintings have jagged lines, strong strokes, and vibrant, overflowing colors. On stage, Blackwell stands with his cane in front of his Jazz-inspired paintings and sings or recites poetry.

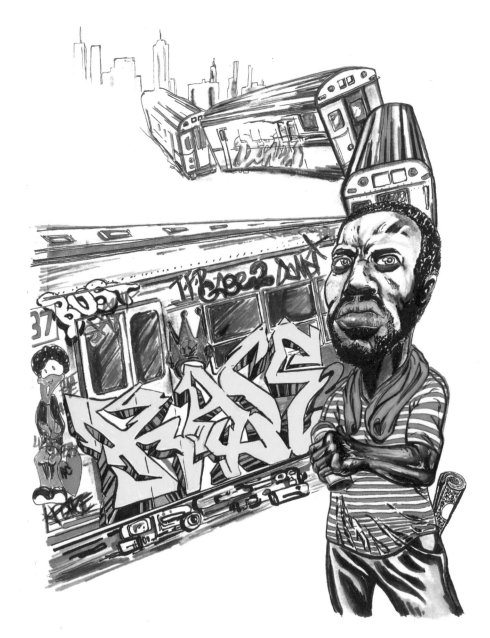

Kase2, 2017, by Asian Robles

Kase2 aka King Kase2 (Born Jeff Brown)
1958–2011

Hip-Hop is more than rap music! Visual art like graffiti, spray-painting on public walls, is also part of Hip-Hop. Kase2 lost his right arm in a subway accident when he was just ten years old. He taught himself to draw and paint with his left hand, later becoming one of the best graffiti artists and greatest contributors to the birth of Hip-Hop in the 1970s. By 1976, Kase2 had painted graffiti on over fifty subway trains in New York City. Can you imagine seeing your artwork every day on the subway?

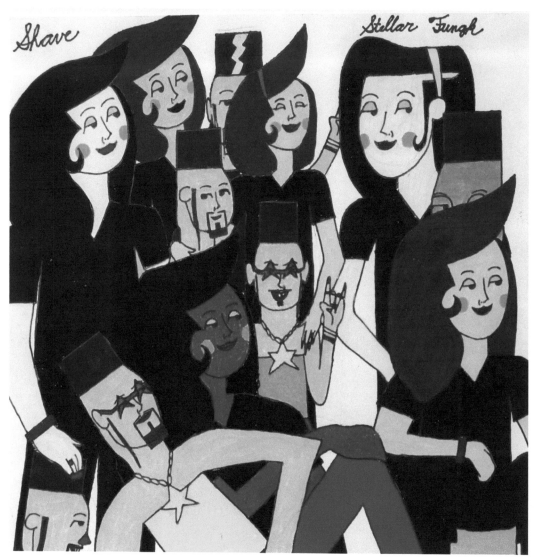

Stellar Fungk, by Gerone Spruill

Gerone Spruill

1973–Present

What colors make up your community? What music fills your streets? For Gerone Spruill, Black and Brown people fill the streets of Oakland, and the soundtrack of the city is a mixture of Soul and Hip-Hop. Spruill is an **autistic** painter, rapper, and DJ. He creates colorful drawings and comic book stories about his beloved "Chocolate City," Oakland.

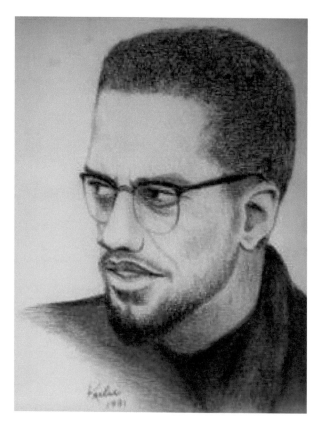

El Hajj Malik, 1991, by Kiilu Nyasha

Kiilu Nyasha

1939–Present

Kiilu Nyasha is a portrait artist and lifelong activist against injustice. Nyasha was diagnosed with **polymyositis** as a young mother. She spent years in and out of the hospital and today uses a wheelchair. She was a member of the Black Panther Party where she worked as a legal secretary and coordinated the free breakfast program to feed hungry kids. Over her long life, she has fought with love from her wheelchair for the liberation of Africans, Asians, Haitians, Latin Americans, and Palestinians. Today Nyasha holds her grandchildren in her wheelchair, just like she did with her own children. For her, disability is an everyday experience full of warmth and love for her family and Black community.

Butter Knife Blues

He is smooth like butter
Some thought he played out of tune
Plucking with a butter knife
In his claw gimp hands

Poor, polio, police raid
Left him black & blue
Healing & expressing his blues
Mother's medicine

Gave him confidence
To create his own sound
CeDell Davis, Butter Knife Bluesman
Born in Helena, Arkansas

Blues journalists, Robert Palmer & Eric Clapton
Like Aretha had nothing but R.E.S.P.E.C.T. for this man

Limping to the hardest club in town

Where love was absent but fights were constant

Pop, pop two in the air

CeDell was trampled

Suspended in mid-air

Legs & arms in tractions

6 months in the hospital

Wheelchair blues with a butter knife

"You See Me Laughin'

The Last of the Hill Country Bluesmen" DVD

CeDell talked about his life

This man is the Blues

Like Ray Charles's "Born To Lose"

CeDell lost his legs

But found his rhythm

Jammed with Peter Buck of REM

Blues & Rock

Guitar solo rocking the pit

Jimmy Hendrix played left handed

Gene Simmons plays with his tongue

Tony Melendez plays with his feet

Butter knife is not so strange

CeDell added his own page in music history

He wasn't afraid to put it out there

Full color picture, wheelchair & all

On the cover of his CDs

Overlooked, fame passed him by

His real name, Ellis Davis

Hear this, screech of his guitar

The hoarse of his voice

Made people covered their ears
Until they understood and were trained
To hear greatness and uniqueness
No one could copy

Disability is beauty & rhythm
Every time you pick up a butter knife
Stop & listen

CeDell Davis's Butter Knife Blues
On every family dinner & candle light table

"Butter Knife Blues" by Leroy F. Moore Jr.
About CeDell Davis (1927-Present)
First published in *Black Kripple Delivers Poetry & Lyrics*
Poetic Matrix Press, 2015

Musicians

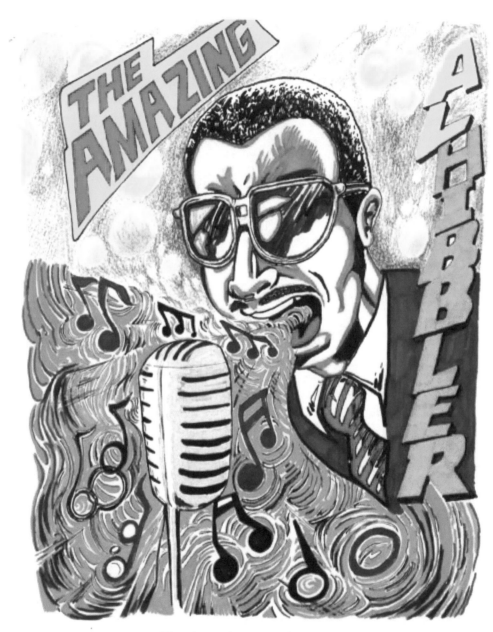

The Amazing Al Hibbler, 2017, by Asian Robles

Albert George "Al" Hibbler

1915-2001

Growing up Black and blind in Arkansas in the early 1900s was not easy. Al Hibbler's voice was his ticket to success. He became the first Black singer to have a radio program in Little Rock, Arkansas. He sang Rhythm and Blues, Jazz, and popular music, and even sang for Duke Ellington's orchestra for eight years! Hibbler was involved in the **Civil Rights Movement** of the 1960s and marched with Martin Luther King Jr.

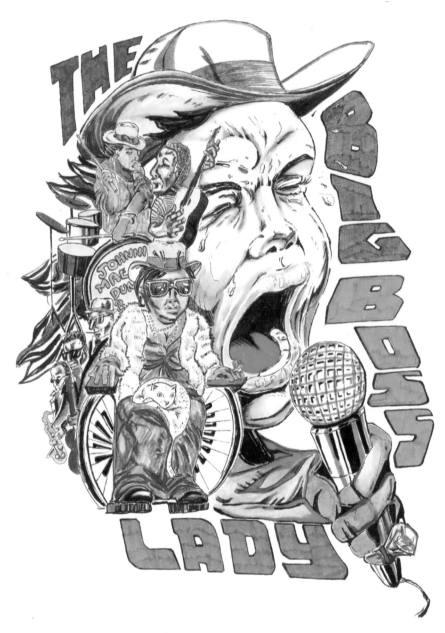

Johnnie Mae Dunson, 2017, by Asian Robles

Johnnie Mae Dunson

1921–2007

When two-year-old Johnnie Mae Dunson got sick with an infection that left her with a weakened heart, doctors told her parents she wouldn't live to be an adult. Dunson proved them wrong by not only living to her late 80s, but by turning the Chicago Blues scene upside down for over 50 years! Dunson was the first female Blues drummer, she was a singer, and she also wrote hundreds of Blues songs. Later in life when she used a cane and a wheelchair, she started a small business decorating canes.

Ode to Johnnie Mae Dunson

How can I write about you?
Am I too young, need to learn more
I hear you "let it go son, speak the truth!"

Now I'm ready just like Langston Hughes
I'll talk my blues song on stages
Big Boss Lady still rattling cages

Chicago's wind blows
Your lyrics through Maxwell Street
Where you used to be

From cane to wheelchair
Doctors said you had a weak heart
Wouldn't survive past fourteen

First Blues lady on the drums
Making every heart beat
Raw & gritty people got up on their feet
Record business cheated

Gave no respect
Just take take take
Was collecting cans from the streets

Books and books of songs
Men begging her to write
But never copyright

Got ripped off blind
Just like blind Bluesmen
Should have worked together but didn't happen
Johnnie wrote for Jimmy Reed
Women always behind the scenes
Pulling the strings

In 2000 Big Boss Lady appeared

Her first and only from her stomach to your ear

Deep dark Blues 60 plus years made up her career

Back then men controlled everything

Sexism in the music industry

Forced to be Big Boss Lady

Was that or nothing

Forget about the bling bling

Just write the true Blues Herstory

With the Black women & disability community

How am I doing Big Boss Lady

She told me, "son bring it back home"

Ok ok for you out there and everywhere

Johnnie Mae told me to say

She's the Mother & Grandmother of the Blues

Chicago, you got to know you hear me Chicago you got

to know

"Ode to Johnnie Mae Dunson" by Leroy F. Moore Jr.
First published in *Black Kripple Delivers Poetry & Lyrics*
Poetic Matrix Press, 2015

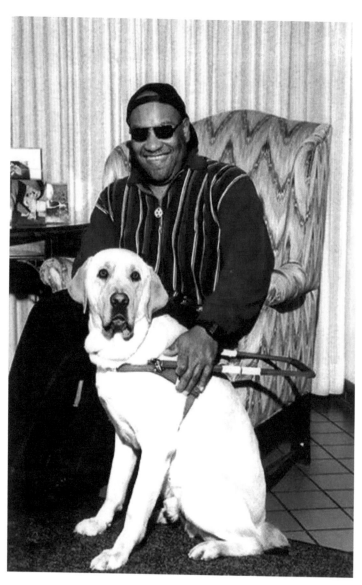

Joe Capers and his guide dog Tenor
Oakland, California, circa 1990s

Joe Capers aka Blind Joe
1957–2002

If you were in Oakland in the 80s and 90s, you'd have heard the likes of Tony! Toni! Toné!, a young MC Hammer, Digital Underground, Too $hort, and Dawn Robinson of En Vogue. Joe Capers, aka Blind Joe, a blind musician and producer, built the first completely accessible and affordable studio in the San Francisco Bay Area. To recognize his contribution to the arts, in 2013 the City of Oakland officially declared the month of August to be Joe Capers' Month.

Joe Capers Lives on Every August

She told me the story
Little boy in the bathroom
So many interesting things
To play with

Just like a kid
Went for what mother
Told him not to do

Drano cleaner in his hands
Holes on top
One drop of warm water
Then boom, Blind Joe was born

Losing his sight slowly like Ray Charles
Retreating inward banging on furniture

Mom bought him drums and other instruments
That opened his creative musical doors

Black Blind with rhythm
No relying on others
This blind man built his own studio
Gave musicians of color a place to go

Playing jokes on his people
Turning off the lights
Screams in the dark
Laughing with a smile so bright

Not everything was right
Producing hit after hit for others
Joe Capers experienced the double edge sword of
Blind Blues musicians
I don't have to explain myself anymore

Give give give

He kept on giving

To the newly blind

Before ADA disability rights

The saying, a dog is a man's best friend

Meant so much more when Joe met Tenor

More than an eye seeing dog more like a family member

Man and his best friend buried side by side

Now we remember Black August sounds

Gold Album & the opening of J Jam

Every year in the hottest month

Joe Capers will ring throughout Oaktown

"Joe Capers Lives on Every August" by Leroy F. Moore Jr.

About Joe Capers (1957–2002)

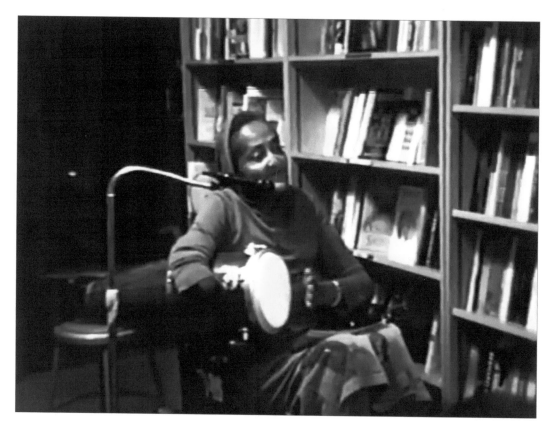

Still frame of Celeste White, Disabled Poets and Artists of Color
San Francisco, California, circa 1995

Celeste White

1945–2000

What did you learn in school today? When Celeste White took a Black poetry class in the 1970s, she was inspired to be a poet and singer. White wrote about her experiences as a Black disabled young mother who used a wheelchair. She was also active in the **Disability Rights Movement** in the San Francisco Bay Area.

"Songwriting and poetry has been a way to name and claim my life and move forward." —Celeste White

She Is

She is with us
Singing her beautiful songs

She is music to our ears
Making our hips sway to her beat

She is mother, friend, and songwriter
Teaching us how to be a healer

She is drop-dead gorgeous
Her big heart is her fame making her famous

She is a proud brown skin disabled sister
Wheeling and dealing in her wheelchair

She is an angel
Watching over us

She is snow and rain
She is an icy cold drink on a hot summer day

She is tissue
Wiping away our tears

She is a band-aide
Covering our open wounds

She is with us
Morning, noon and night

She is a pair of wings
Carrying us to a higher plane

She is a spoonful of medicine
Healing our sick society

She is the law
That can't be broken

She is human
Making mistakes and correcting them

Celeste White is
Because she is within us

"She Is" by Leroy F. Moore Jr.
First published in *Black Kripple Delivers Poetry & Lyrics*
Poetic Matrix Press, 2015

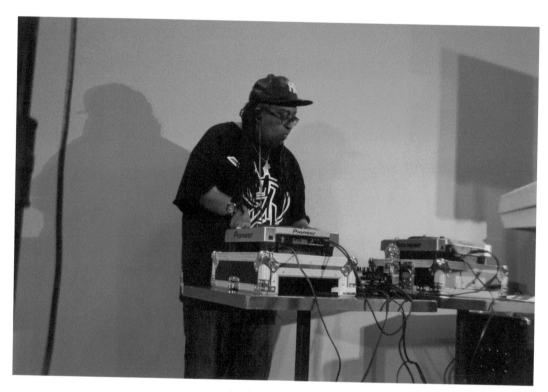

Rob Da' Noize Temple, Tangled Art Festival
Toronto, Canada, 2014

Rob Da' Noize Temple

1953–Present

Rob Da' Noize Temple was born with music in his soul. He was also born with **Erb's palsy**, and at the age of six, he learned to play the keyboard with one arm. He started his first band at the age of thirteen. Even though he has faced a lot of **discrimination** from the music industry against his disability, Temple has never let that stop him from making music! Today Temple is touring as a keyboardist and DJ for Rapper's Delight aka The Sugar Hill Gang, and he has just completed the music soundtrack for the new documentary *I Want My Name Back*. Temple finally found his musical home when he met Leroy F. Moore Jr. and formed Krip-Hop Nation, an international network of disabled musicians.

Toni Hickman, Houston, Texas, 2016

Toni Hickman

1974–Present

Toni Hickman was on her way to stardom in the music industry when she had a **stroke**. Her doctors told her she would never walk or talk again. Today, she is back to creating Hip-Hop. Hickman's first two albums, *Cripple Pretty* and *Unbroken*, reflect on her experiences with disability, and some of her music videos star other disabled women.

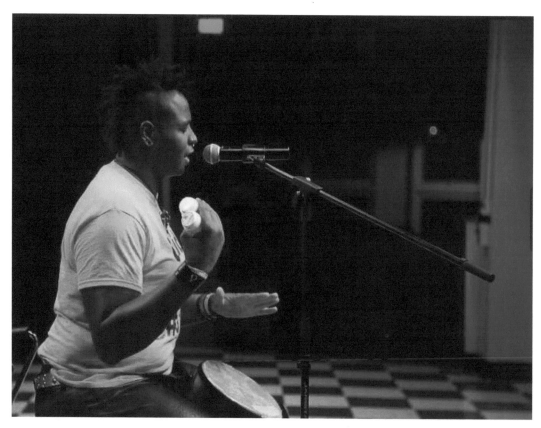

Vita E. Cleveland at the University of North Carolina Charlotte, 2016
photo by Katie Simmons-Barth

Vita E. Cleveland

1989–Present

As a Black **trans** woman with **anxiety**, **depression**, and **insomnia**, Vita E. Cleveland uses music and poetry to speak out about the experiences of transgender women of color. Cleveland has brought her rhythms and rhymes to both the stage and the classroom for the last thirteen years as a performer and drum teacher. She is the social media coordinator for the first talent agency for Black and Brown trans and **queer** people. She hopes that by making art, people with bodies and brains like hers will know that they are not alone and that they are loved, no matter what the world says about them.

King of The Keys

Groove me
King of The Keys
You had all the keys
Opening up all of us
To many dreams

My Black disabled brother
We were together
Music and advocacy
Changing our community

Singing Robert Winters
But you're the Magic Man
Yes, I understand
Disabled musicians struggle summer, spring, fall, and winter

Told us to face the music
Now I'm lovesick
By your message

Grooving in your grooves
I'm standing on my roof
Singing "Somebody Loves You"

King of The Keys
Unlocking the minds of the youth
In Church and in schools

God is
He took you back home
Your keys live on

I promise to put you in my book

Playing your verses and hooks

On the station you helped, KPOO

Yes today we might have the Blues

We also sing your Jazz, R&B, Gospel

Telling all the people

About you, King of The Keys

"King of the Keys" by Leroy F. Moore Jr.
About Brigardo Groves (1950–2010)
First published in *Black Kripple Delivers Poetry & Lyrics*
Poetic Matrix Press, 2015

Dancers

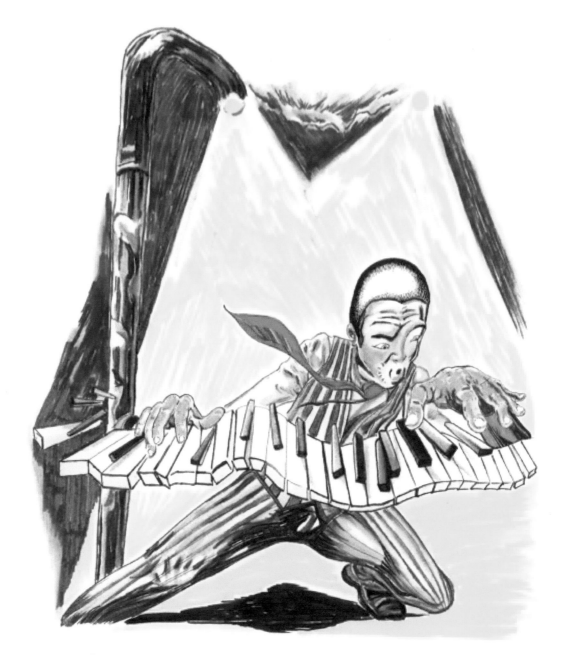

Albert Clemens aka Cripple Clarence Lofton, 2017, by Asian Robles

Albert Clemens
aka Cripple Clarence Lofton
1887–1957

Can you dance, sing, whistle, and play an instrument all at the same time? Albert Clemens could, and did! Clemens got his stage name—Cripple Clarence Lofton— because he was born with a limp. He was a tap dancer, a boogie-woogie piano player and singer, and even owned a night club in Chicago in the 1940s.

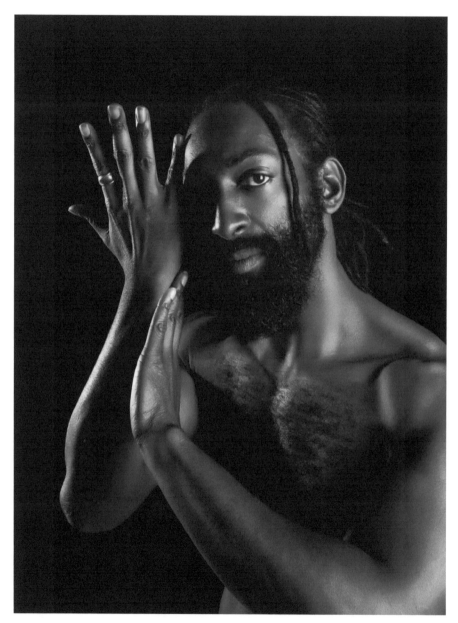

Antoine Hunter

Antoine Hunter

1980–Present

You don't have to hear music to experience it. You can feel the beat, the vibration of bass guitar, and the pounding of the drums. That's what Antoine Hunter does. Hunter is a Deaf choreographer, ballet and Jazz dancer, and dance instructor. His Oakland-based dance company, the Urban Jazz Dance Company, incorporates **American Sign Language** into its dances.

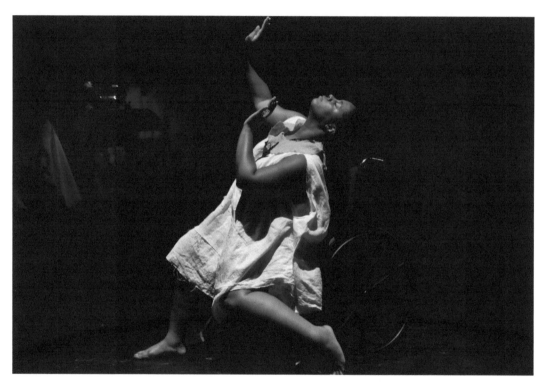

India Harville, Inclusive Interdisciplinary Ensemble,
from *In the Beginning God Created Difference,*
Cal State East Bay, Hayward, 2016, photo by Ben Ailes

India Harville

1981–Present

"If you can breathe, you can dance." Dance and movement have helped India Harville, a **queer** Black disabled woman, cope with her **hemiplegic migraines**. Today she shares the healing gift of dance as a teacher. In her wheelchair, Harville teaches people how to dance on their feet, on wheels, on crutches, or with a cane.

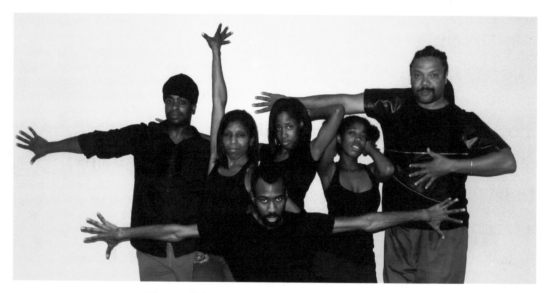

The Wild Zappers and the National Deaf Dance Theater
Washington D.C., 2015, photo by Jeff Pecot

The Wild Zappers

1989–Present

What brought Fred Beam, Warren Snipe, Irvine Stewart, Ronnie Bradley, Kris Pumphrey, Sam Franklin, Buck Rogers, and George Azmaveth together to form The Wild Zappers? Dance and Deafness! The members of the first Black Deaf dance company dance Hip-Hop and Funk. They combine **American Sign Language** and dance in order to educate Deaf and hearing communities about American Sign Language.

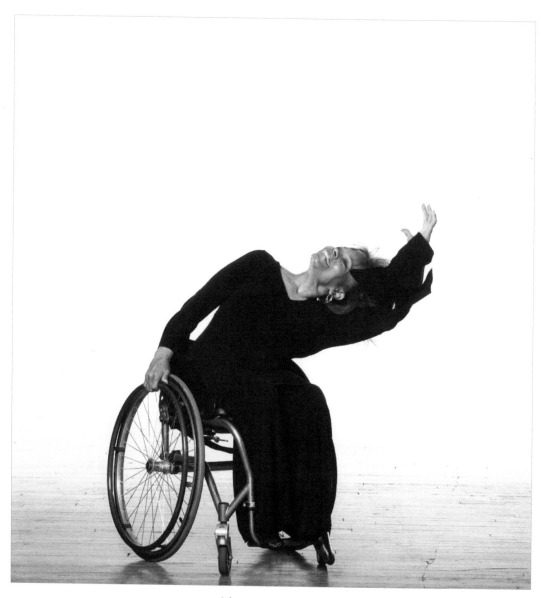

Alana Yvonne Wallace, Chicago, Illinois, 2010
photo by William Frederking

Alana Yvonne Wallace

1951–Present

When you were little, what did you want to be when you grew up? Alana Yvonne Wallace has known since she was a child that she was born to perform! Wallace got **polio** when she was five years old and uses a wheelchair. The wheelchair is an important part of dancing for Wallace—she can move in ways she couldn't on two feet. Wallace founded Dance>Detour, Chicago's first professional dance company with disabled and nondisabled dancers.

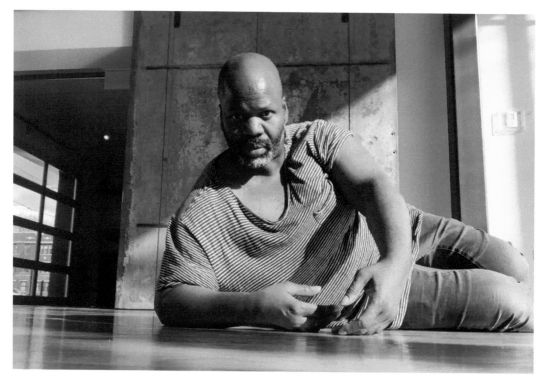

Barak adé Soleil, Chicago, Illinois, 2016

Barak adé Soleil

1970–Present

For twenty-five years, Barak adé Soleil has used movement to explore the beauty and wholeness of the Black disabled body. For Soleil, disability is an opportunity for creativity and exploration. He uses crutches, a wheelchair, the floor, and walls to support his dance and movement. He incorporates techniques from **queer** culture, disability arts, and the **African diaspora** in his art. Soleil founded D UNDERBELLY, a network for artists of color.

Actors & Actresses

Lee Williams Sr., Oakland, California

Lee Williams

1937–2017

Athlete, painter, singer, actor, poet, and father,
Lee Williams did it all! He played Porgy in the Black
opera *Porgy & Bess* at the Black Repertory Theater
in Berkeley, made it on the big screen with
Whoopie Goldberg and Ted Danson in the movie
Made in America, and made his first solo CD in
2006 called *PhaseV*. Lee Williams did all this and
more from his wheelchair with love and grace.

Michelle Banks, 2011, photo by Clinton Brandhagen

Michelle Banks

1968–Present

We all want to see characters on TV who look like us and share our life experiences. Thanks to Michelle Banks, Black Deaf women can see themselves represented in theater. She created Onyx Theater Company, the first Deaf theater company for people of color. Banks also starred in a movie about a young Black Deaf woman called *Compensation*, and has a one-woman show about her reflections on Black Deaf culture.

Lynn Manning

Lynn Manning

1955–2015

Would you like to write a play about your life story?
Lynn Manning wrote the play *Weights* about growing
up in poverty, about becoming blind as a young adult,
and about his life as an actor, poet, and playwright.
He was also World Champion of blind judo and won
a silver medal for the U.S. in the Paralympics in 1992.
One of Manning's last plays was a collaboration with
Leroy F. Moore Jr. about Black disabled Hip-Hop
artists called *It's A Krip-Hop Nation*.

Kei'Arie "Cookie" Tatum, 2015, photo by Laura Burke

Kei'Arie "Cookie" Tatum
2002–Present

Have you ever wondered how child movie stars get their start? Thirteen-year-old Kei'Arie "Cookie" Tatum's family encourages her to follow her dreams and become an actress and model. Tatum starred in a documentary about **Down syndrome** called *I AM MORE*. She uses her acting skills to teach people about Down syndrome and speak out against bullying.

Black Blind with the Blues

Born with 20/20 vision

Father left gave no reason

Mother worked under the hot Florida sun

Brother in the tub

Can't stand up

Going down slow and he feels numb

Eyes become blurred

Can't see the face of his mother

Feels the strong bond between him and her

Now it's only him and his mother

No time for sorrow

"Be independent 'cause I might not be here tomorrow!"

House chores

Cleaning the floors

Black blind and dirt poor

Red Wing Cafe

Was his favorite place

Listening to the boogie-woogie piano play

His talents started to grow

But mom taught him all she knows

"Off to school you must go!"

Separated from his mother and home

Segregated in school

Blacks with Blacks Girls with Girls and so on

Mother is dead and he is confused in his head

Bored at school

No home to go to

Music keeps him alive

Black blind with the blues

Town to town singing about his life

Now people call him the Genius

Pregnant with the Blues

His birth is a blessing to all of us

"Black Blind with the Blues" by Leroy F. Moore Jr.
About Ray Charles (1930–2004)
First published in *Black Kripple Delivers Poetry & Lyrics*
Poetic Matrix Press, 2015

Glossary

Historically, the language used to discuss disability has pushed disabled children, youth, and adults to hide their full identity and culture. Here, I offer some emerging definitions that aim to empower, celebrate human diversity, and transform culture. That being said, language is constantly changing with every generation; it is full of richness, and can have many meanings and interpretations. So, like all the definitions you will encounter, I invite you, reader, to think about these terms and definitions, and talk about and put your own spin on them in ways that fit you, your generation, and the people you love.

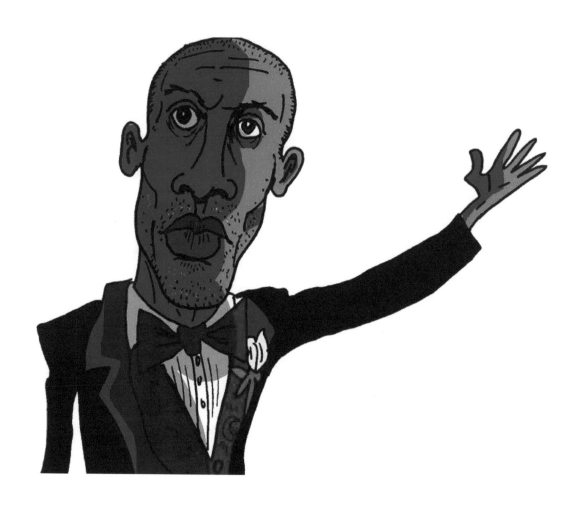

Cartoon of Leroy F. Moore Jr. by Jim Lujan
in the Kounterclockwise film, *FOREVER-LAND*

Acknowledgements

Thanks to Xóchitl Justice Press and their staff for this opportunity. Pam Fadem, Steve Brown, Meagan Morse, Stephen Walrod, and Jane Dunhamn who gave wonderful suggestions for the manuscript. Sara Acevedo and Brianna Dickens for their definition of autistic. My family, especially my sisters, Melissa, Pamela, and Tiny. All the artists in the book, past and present. The stunning artwork of Asian Robles. Last, but not least, the children and youth and their parents and teachers who will read this book!

Thank you. Thank you!

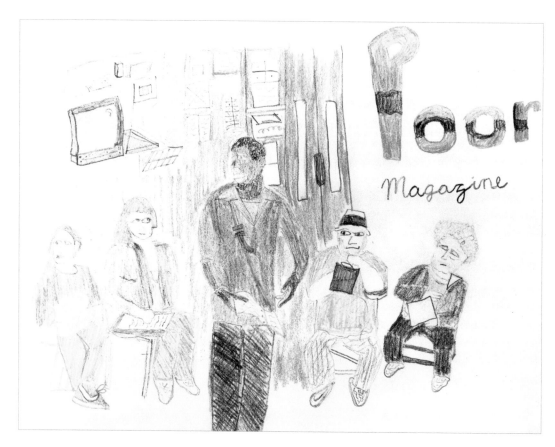

Leroy F. Moore Jr. teaching at Poor Magazine
by Tiburcio Gray Garcia

About the Author

Leroy F. Moore Jr. is a poet, journalist, and cofounder of many organizations for disabled people, including the National Black Disability Coalition. He also started an international music collective for disabled musicians called Krip-Hop Nation. In his work, he has traveled to many cities and countries. He has spent many years collecting books, music, articles, and visual art by Black disabled artists. He lives in Berkeley, California.

About the Editors

Nicola A. McClung, PhD, and Emily A. Nusbaum, PhD, are co-founders of the Disability & Equity Initiative at the University of San Francisco in California. We are committed to collective, transformative, and anti-oppressive work that gives voice to first-person perspectives on disability and equity in education and the arts. Nicola McClung is a co-founder of Xóchitl Justice Press.

Xóchitl Justice Press
A nonprofit organization focusing on community partnerships, research, teaching, and publishing.

CPSIA information can be obtained
at www.ICGtesting.com
Printed in the USA
LVHW070012150319
610748LV00002B/7/P